THE
Natural World
IN
Poetry

DANE ANN SMITH-JOHNSEN

Order this book online at www.trafford.com
or email orders@trafford.com

Most Trafford titles are also available at major online book retailers.

Printed in the United States of America.

ISBN: 978-1-4669-8151-5 (sc)
ISBN: 978-1-4669-8150-8 (e)

Trafford rev. 02/16/2013

North America & international
toll-free: 1 888 232 4444 (USA & Canada)
phone: 250 383 6864 ♦ fax: 812 355 4082

DEDICATION

The Natural World in Poetry *is dedicated to my children, who became expert campers at an early age during many of their childhood summers. Memories of those happy days exploring with them are interwoven in my heart and throughout my poetry. And to my husband and partner in life, who read every poem that I have written more than once and who steadfastly encouraged me with loving support.*

ACKNOWLEDGEMENT

I would like to thank Love Blake of Trafford Publishing Company for her persistence in encouraging me to overcome my fears of self-publishing, which has made this book a reality.

I would also like to thank Earl Thomas and Evan Villadores, and the rest of the production team including the cover design team for working closely with me in making this book more beautiful than I had imagined.

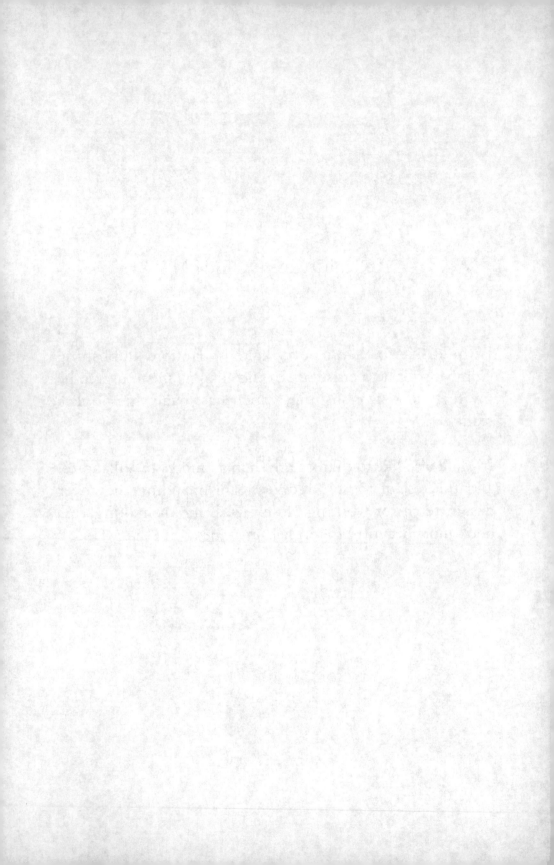

THE NATURAL WORLD IN POETRY
A LISTING OF POEMS:

A Soul Like You, Butterfly

Metamorphosis
Miraculously renewed.
Beautifully changed.
Life once imprisoned.
Escapes! Empowered to fly.
Flitters on flowers,
Nourished for hours.
Sometimes gliding just for fun.
Underneath the sun
Wandering subdued.
Laying fresh butterfly eggs.
Designed just for you.
Larva, cocoon, grew.
Exquisitely surreal…
(Like a soul reborn…)

Emerging Butterfly Photographer Dane Ann Smith-Johnsen

A Spider's Patience

Today, the third day you were there.
Waiting in quiet stillness, watching.
Golden reflections caught the sun's glare.
Motionless. Patiently waiting.

Hoping the prize would pass your way.
Hunger pangs grow stronger, for prey.
Hidden among the trees, you stay.
Silent fearlessness is your way.

People pass, but do not notice.
Practically in plain sight you watch.
A successful hunt this day, nice!
This feast will add another notch.

In amazement, I stop to stare.
And what do I see, have you trapped?
Curled up darkly with silken care.
The spider gooey juices lapped.

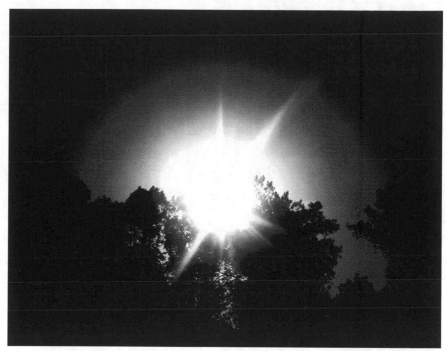

A Spot of Heaven Photographer Dane Smith-Johnsen

A Spot of Heaven

When dawn greets the morning sun,
Peeking through blanketed skies.
A spot of heaven shines its light.
And clouds cover a grateful earth.

Abiding Beauty

Above the fern at the forest's edge, a butterfly gracefully
 glides.
Beautiful yellow flittering near tastes the sugary buttercup.
Flashing sculptured wings, happily spreading, upon a placid
 breeze rides.
The wild flower bed will not subside as the beauty drifts up
 and up.

Long slender wings black with light stripes, zebra long-wings
 come hovering. Sight!
Seemingly weak, suspended in air, they waft between passion
 vine blooms.
Family ties. Who would realize? Communally sleeping at
 night.
Seven, eight, no, eleven there were hovering beneath the
 new moon.

Dipping, floating, skipping in the breeze, viceroys
 mimicking regal lines.
Willow branches and cherry trees, disguised, chrysalis
 covered with leaves.
Colorful viceroys mimic. Hiding in willows they will sleep
 and dine.
Majestic, monarchs on milkweed feast; then, migrate to
 Mexico's trees

Beautiful red-spotted purple or is it a pipevine swallowtail?
To grace blackjack cherries and willows that grows at the
woodlands door.
Flipping. Flying! Bright orange. Fritillary finds food from
flowers, frail.
Delightfully sips on passion vines, warming in the sun as
before.

Spring's sweet trip into summer slips; too soon the
butterflies will be gone.
Chrysalises metamorphose on: twigs, beneath leaves, cleave
to host trees.
Birds fly south 'til caterpillars emerge. Then, return to sing
hunger's song.
Cycles of life! Interlocking beauty. Upon distant pasts
proceeds.

Human hearts, overwhelmed, skip beats. And God's beauty
bestows souls' relief.
When in love's peace and solitude, man rests in nature's
lovely abode.
There is no loss of life or pain, nor hurt, that can lessen
one's belief.
Abiding beauty becomes a crown when on the straight and
narrow road.

Amber Morning

Amber light slivers.
Illumine aqua ripples.
Welcome crystal dawn.

Ancient Waterfall; Modern Man

The whispered sounds of woodland winds touch leaves.
And cottontails retreat across their fields.
The distant deer graze safely between trees.
And man submits to nature's beauty… Yields.
The grandeurs take a man down to his knees.
And reverence wakes the soul as man sees.
Beyond the path cool water's ancient flow.
Continues throughout time; to life bestow.

Ancient Waters

A glimpse of the sea
Enchanted by ebony
Enlightens nature.

Basalt periphery
Bathed in Miasma Ocean
Beguiles pastel clouds.

Silver embellished
Melds beautiful horizons
Quietly praying.

Salty silvery-spew
Embrace, cleanse, and soothe the past.
Mystify mankind.

As Dusk Drew Near...

As dusk drew near, and light grew dim, strength strolled.
Serenely, near the flowing river… still.
Breathtaking power sauntered on that knoll.
Though giant fallen trees dotted the hill.
A bull moose posed and distantly cajoled.
Enticing nearby human to the sill.
In elegance his antlers were displayed.
Resplendently, at majesty, we gazed.

Asserting Dominion

Multiplicity and variety insured life.
Purposeful planning in the beginning
Applied upon eons past and future.
God's beautiful plan materialized.
Pride rationalized away our Creator.
Greed wreaked havoc upon creation.
Asserting unrighteous dominion,
Man has mutated his future.

Banyan Trees

Surreal, supports from bough to ground
Dangle from branches earthward bound.
Supporting structures grow from limbs.
And flourish until daylight dims.
This weirdest tree stands not alone.
From dangling roots are trunks soon grown.

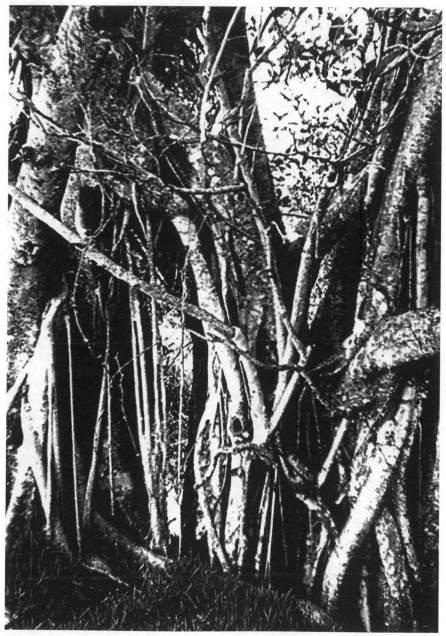

Banyan Tree Trunk By Dane Smith-Johnsen

Barren Oak By Dane Smith-Johnsen

Barren Tree

Majestic remains on a mountainside,
Dead trees, watching as life passes by,
Remembering youth and fresh green scents.
No leaves to rustle by and by... sigh.

Burned forests stripped of their life and bark.
Lifeless trees stand; dreaming rescinded.
Anxiety waits; seedlings embark.
Hope remains where fire rage blasted.

Volcanic eruptions... dreadful fate—
Trees stare; wildlife scampers and scurries.
Creatures run, for some it is too late.
The outcome, starkness amid flurries.

Mountain pine beetles eat luscious pines.
Devoured alive where life once thrived,
Tall they stand as to death hope resigns.
Many new seedlings and life lie, deprived.

Blighted by man or natural rage.
Standing strong against rotting decay.
Some trees remain in their deadly cage.
Stricken to the heart, gracefully allay—

Beyond the Window

Escape is there. Beyond the window, songs of nature call.
The stillness of the evening sounds the flicker's serenade.
He sings, and sings, and sings again; his mate flitters near.
Silence falls upon desire. They rest, for love is dear.

Subtle chirps of hope burst forth from all corners of night.
In life 'til death heart's love songs beg; share another flight.
Human minds anticipate sweet dreams, will upon them fall;
But, lost loves learned by heart return defeating hopes' call.

Imaginary days of trust turn pale and vanish with the dawn.
Sadly, love dries up too soon, deceit makes one a pawn.
So, hope and pray for blessings and a good life evermore.
Then, when love falls upon trust's heart, open up the door.

Biodiversity

Biodiversity insured life
Man wreaked havoc and doubted,
Spitting in God's face.

Birds Heard

Serenading on the breeze.
Songbirds sing their melody.
Loving life within the trees.
Seemingly breathing carefree.

Woodpeckers tap forest drums.
Tasty treats, rhythmical beat.
Meanwhile all of nature hums.
Overcoming all defeat.

Graceful majesty betrothed.
Eagles fly high… two in love.
Watching nature down below.
Circling, courting above.

Warning cries they all join in.
Friend or foe they seem to know.
Rattlesnake! Screeches begin.
Mocking birds, cardinals and crow.

And so it is that birds are heard.
Many days and many nights
Building and living… strength gird.
Singing their loving with flights.

Black-Eyed — Susan

Oh Black-eyed-Susan, bright and true.
Withstand great heat without adieu.
While perky rays protect your crown.
The buzzing bees come humming 'round.

Beside the road you often grow.
Oh Black-eyed-Susan, bright and true.
And when your seeds upon winds blow,
Your sovereign flower breathes there, too.

Dear golden petals drinking dew.
Persistence-power lives in you.
Oh Black-eyed-Susan, bright and true.
My favorite, you, wins honors due.

Each time I take a walk in spring,
And ponder lessons learned from you.
Your simple flower makes me sing.
Oh Black-eyed-Susan, bright and true.

Blue Spruce

Oh,
silvery-blue
scented needles
fragrance permeates
Freshness.
Billions of years preceding
Jesus Christ, trees naturalized.
Six to eight centuries, standing tall.
But now, man steals your life in your prime.
Little trees die.
Oh, Spruce with perfect shape, will you grow up?
Man, look around and think before cutting
young blue spruce down. If tree life abounds, all life thrives.
Man must understand to survive! The Colorado Rockies
and the Utah timberlands displayed splendid sights.
Now, thousands, of strong trees are chopped down yearly.
In Christian lands around the world, mankind celebrates
Jesus Christ's birth.
Spruce trees face a familiar plight. Guiltless, they too
are crucified chopped down in their prime. Life
stripped. I guess folks just don't realize that as
trees decorate their homes, potential dies.
There is no longer a chance to be become 115 feet of
Blue tinted magnificence!
Replenish!
Replenish!
Replenish!

Busy-bee

Brightly shinning skies.
Black-eyed-Susan's blooms reach high.
The sun, smiling sighs.

Flittering free, "Busy-bee"
Buzzing here and buzzing there.
Sweet nectars sugar tasty.
Sipping flowers everywhere.

Pollinated fruits for wines.
Visiting vines where life climbed.
Walking on the edge of birth.
Nature's charm splendor refined.

Every single plant that lives
Plays part in the grandest scheme.
Nature, together life gives.
Flittering free, "Busy-bee"

Cadmium-orange

Amazing beauty,
Cadmium-orange explosion
Brightens sky and sea.

Call of the Wild

Safari.
Rainless African plains call.
The fittest survive.

Category 5

Oh black horizon,
Golden sunrise demolished.
Wind and rain consumed.

Caterpillar Gifts

Above the fern at the forest's edge, yellow butterflies,
Stunning sulphurs flitter; taste the sugary buttercup.
Flashing wings blissfully spread; upon a placid breeze rides.
Wild flower beds do not subside; splendor drifts up and up.
Beautiful red-spotted purples, or pipevine swallowtails.
Visit blackjack cherry trees growing at the woodlands door.
Ravenous, gulf fritillary, fly the flowering trail.
Delightfully sip passion vine, warmed by the sun once more.
Sleek, black, showy, long-wings; zebra stripes hovering in fight!
Seemingly fragile poised in air, float among vines and blooms.
Family ties, understood; they sleep together at night.
Seven, eight, no, eleven there were hovering that noon.
Dipping, floating, skipping the breeze, viceroys, as regal lines.
Willow branches, cherry trees, chrysalis hidden in leaves.
Viceroys, regally mimic; then, sleep in willows they find.
Majestic monarchs, milkweed feasts, flights to Mexico's trees.
Spring's new life, summer, then fall; soon butterflies shall
 be gone.
Chrysalises metamorphose on twigs, beneath host trees…
 leaves.
Birds fly south singing hunger's song; in spring they come
 back strong.
Caterpillar's gifts, as for eons past, life cycles… needs.

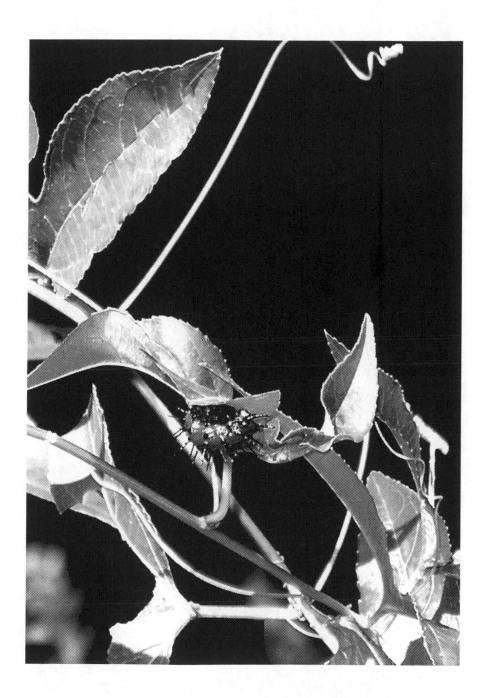

Chicks

Chicks
Cheeping
Cracking eggs
Burst their way out
Birth

Colors and Perception

A world with colors bright and true.
Within reflecting eyes renews.

Beyond the beauty there is need.
The atoms know light's secret deed.

Each color has a special task.
Reflected light unfolds its mask.

And souls intrigued by rainbows' shine.
Shall once in heaven, know God's rhyme!

Awareness faltered by man's play.
Upon subconscious minds do prey.

Discernments stored in distant pasts.
Awaken truths that have been cast.

Perception can great wisdoms find.
Reflected to us from God's mind.

Cradle of Beauty

Oh "River of Grass" diverse life spawned.
Teeming with life many days bygone.
Beautiful sunrises paint skies each dawn.
Flora and fauna, endangered, withdrawn.

Glorious wetlands meander around.
Twisting and wandering, flow, southward bound.
Shingle Creek, Everglade headwaters, resound.
Winding as it trickles from town to town.

Beautiful wetlands watch anhinga fly.
Green turtles and wood storks cautiously sigh.
Florida panthers and manatee cry.
Drying "River of Grass", newborn die.

Saw grass prairies, diverse trees, mangrove swamps
The home where gators and crocodiles romp
There was no greater beauty, elegance, or pomp.
The "River of Grass", needs your help; please be prompt.

Creeping Charlie

Oh, Creeping Charlie:
Beautiful, orange, hanging vine
Dazzles autumn days.

Crickets Rubbing Legs

Crickets rubbing legs
Serenade their lover's right
Singing through the night.

Crooning Midnight

Shining stars sparkle.
Midnight rituals begin.
Creatures start crooning.

Crying Chrysanthemum

Radiate sunshine.
Arrayed in natural beauty.
Glow before the world.
Rejoice in friendships.
Applaud thy many blessings.
Anticipate love.
Nourish in splendor,
Weep not; sing enchanted songs.
Ooze thy fresh nectar.
Let thy fragrance spread.
Prepare sweets for honeybees.
Fulfilling their life's needs.
Ultimate joy shall be yours.
And your life shall bring forth.

Cucumber Information

Look! Cucumber information.
Written with alliteration! Smiles!
Crispy, crunchy cucumbers
Can clearly be considered essential.
Almost all salad combinations
Contain luscious cool cucumbers.
And they are absolutely always
Necessary when canning pickles.
Yum. Yum. Homemade pickles!

DNA Became

Before life was formed.
Planet earth saw its first morn.
Bleak. Barren. Forlorn.
Then, God formed His creations.
And DNA became—

Dappled Apple

There once was a juicy Gala Apple.
Her redness had a light yellow dapple.
She was a healthy sweet treat.
Fruit that fat people eat.
Gala Apple, "Don't go to chapel!"
Unwisely Gala Apple went to church
She sat on a bench made of birch.
Three children sat near.
One ate her, Oh dear!
Soon, her core upon the floor did lurch.
She was a cherished, polished fine apple.
I had forewarned; never go to chapel.
The yellow highlights she bore,
Didn't save her like before.
Gulped down to the core. Sad. Gala Apple.

Sunrise By Dane Smith-Johnsen

Daybreak

Dawn
First light
Greeting morning dimness.
Inspiring, invigorating, soothing…
Daybreak

Daylight

Daylight peaks.
Passing treetops.
Shining upon life's faith.
Steadfastly proclaiming.
God's creations were made to last.

Daylight Peeks Above Treetops By Dane Smith-Johnsen

Dear Ghost in the Woods

Dear Ghosts in a forest of leaves.
Fallen, colorful, beneath trees.
Hidden, the curious can't see.
Enlightened glimpse; come again, please.

The songbirds all around you sing.
As you waft your way on the breeze.
Hopes that heartfelt expressions ring.
As you bring the soul to its knees.

Were you there in the ancient past?
When terror taunted peaceful days.
Where understanding did not last.
And others mocked the primal ways.

Thank you for showing your faces.
Snapped behind the red lichen tree.
Living dead watching life's paces
Something very few ever see.

Dewdrops Touching the Morning

Silver skies see black silhouettes.
When morning unveils the trees.
The sun, not yet ascended, reaches.
Bringing horizon's newest day.
Crickets lustfully rub their legs.
Together welcoming each new today.
Singing one last romantic song.
A serenade to greet the dawn—
Furious clouds cover the canopy.
Holding the scent of autumn's stay.
Whiffs, rain's ionized bouquet.
Insect muffled; sounds disappear.
Dewdrops touch the morning and know.
Darkness was, but daylight is here.

Dilapidated

Dilapidated
Ravens soar in sapphire skies.
Dreaming of feasting.

Dinner is Served

"Your dinner is served"
Said the inviting aster
to the bumblebee

Earth Recycling

Think: Plate Tectonics
Forever recycling
God's own handiwork.

Entwined

Life entwined as one
Unwittingly suffocates.
Symbiotic death.

Fire Demons

Mountainous sand grains
Hording demons of fire
Steadily lurking
Mounting the depth of their lair.
Ferocious ants beget tears.

Fiery Skies

Fiery bright skies,
Streaked with cadmium-orange,
Reflect God's glory.

Florida Apple Snail

My habitat
Is now endangered!
I am a Florida Apple Snail.
I love in water, lay eggs on land.
I spawn on plants not in the sand
I grow as big as a golf ball in wetlands.
But now, my ecosystem is in danger!
It is becoming hard to breed. My species is ==>
Dry-downs are in the summer... water is what I need.
Please support my Ecosystem Restoration.

```
                                    C
                              F       H
                              O  We   A
                     Drying   O  are  I
                              D dying N
```

Fresh Feast

Beneath the water
Swimming in the deep lagoon
Fearless reptiles search each day
Wanting precious prey,
Power jaws and thrashing tails
Kill while victims' weep and wail.
Alligator's feast—
When all babies have hatched out,
Hatchlings hunt and swim about
Mother watching near
Floating leaves attract her young.
Basking asleep in the sun.

Furious Clouds

Obsessive winds traversed a ceaseless age.
The unpredicted lethal storm drew near.
Soon, ozone sent its whiffs, a toxic stage.
And furious clouds inflicted floods of fear.
The canopy grew silent, oh, dreadful stage.
Winds hurled in howling, never-ending jeer.
Too soon, the sound of insects lost their way.
When darkness stole daylight one stormy day.

Gaiting Fawns

Above blazing celestial dawns
Elegant fawns gait happily
Inventing joys keenly lived.
Meeting nature, offers prayers…
Mountain niches share God's abode.

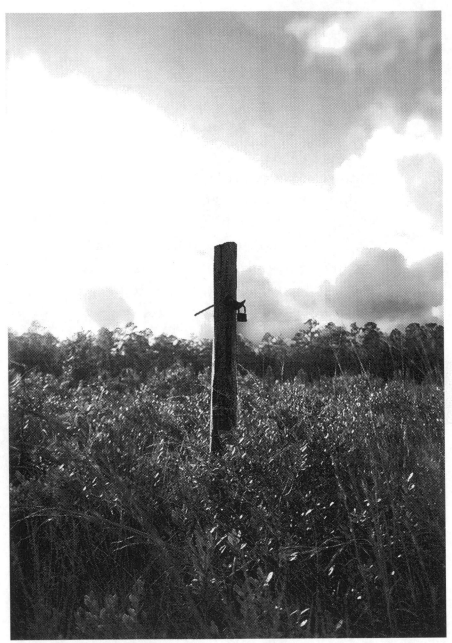

The Forrest Unlocked Photographer Dane Smith-Johnsen

Gallivanting in the Forest

Gallivanting in the forest was a pastime that I loved.
I searched for perfect pictures of God's animals so loved.
The silent stillness living in the air gave me the chills.
Although I shivered many times, I always felt new thrills.

The air was sweetly fragranced by flowers blooming there.
And when it rained upon my face, a smile was never rare.
The freshness of the ozone as it fell down with the rain.
Recharged the earth with oxygen and life again sustained.

God grew… freedom in that air and in nature all around.
My soul was lifted up to Him where miracles abound.
The joy was overwhelming and my soul began to soar.
For woodland gallivanting is so close to heaven's door.

But then, I saw the strangest sight, a lock upon a pole.
It was not very rusty even though it seemed quite old.
Perplexed was I about the lock that stared in nature's face.
In the middle of the wilderness was not a likely place.

First I took a picture; then I pondered and sang songs.
Freedom was in every choice… live right or live wrong.
Suddenly, I was made to see how free a life could be.
And I began to appreciate the choices God gave me.

Gallivanting in the forest was a pastime that I loved.
And never did I go out there without the Lord above.
Thanks to that lock upon a pole, I was no longer confined.
I could walk away or choose to stay; freedom was mine.

Gator and the Coot

Gators harbor invincible strength.
Static force inside their whole length
Like drifting logs, they float, watch, and wait.
Small mammals and birds are their bait.

Hidden beneath the river of grass,
They silently stalk those who pass.
See the coot as it happily scoots.
Arrayed in its gallinule suit.

The beautiful bird swims in the reeds.
Seeking fresh fish on which to feed.
A gator soon spots the floating feast
Murky waters are full the beasts.

The sweet little bird, then, meets its fate.
Chomp, squeak, hunger just can't wait.
The meal, a coot no longer in sight,
Reptilian food that did not fight.

The food chain lives on, and eons pass.
The memory of beauty dies fast.
Gator's tooth is no match in a duel.
Say, goodbye, gorgeous gallinule.

The sudden demise, untimely met.
A dreaded fact of life, I'll bet.
How does one honor the strife, sweet bird?
And remember sad sounds once heard?

The picture snapped before death's cruel toll
Depicts another fragile soul.
Frightened, pounding, fleeing heart is gone.
But the memory lives from dawn to dawn.

A portrait painted to pass through time.
Will honor your journey sublime.
Oh fateful day, the end of the line,
And humans look on as they dine.

Gator Bait

Florida born and Florida bred.
Murky waters watch swimming dread.
Alligators get hungry, too.
I'm sure you knew; it's nothing new.

Pups fall in but cannot swim.
Near riverbanks, their fate is grim.
So, people, take care of your pets.
Then, there will be no regrets.

Bugs and fish aren't all they eat.
Sometimes they want a bigger treat.
So, parents teach your children dear.
Dark black waters are fed by fear.

Gator Territory

Darkness reflecting
In gator territory
Where death lurks below.

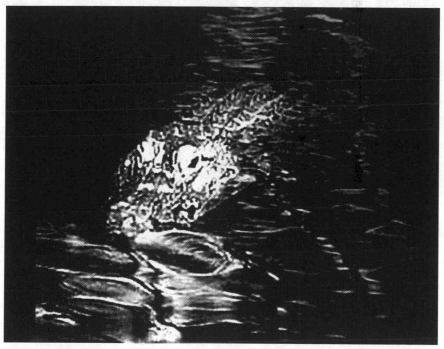

Gator Territory Warm Waters

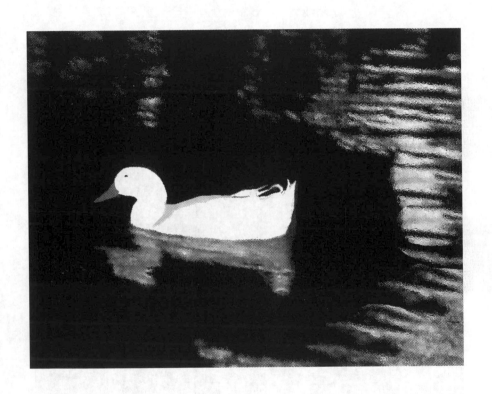

Gazing Stars Shimmering

Gracefully gliding beneath the moonlight
Reflections flicker, shimmering the pond.
Stars gaze down, spreading sweet dreams at night.
Fanciful fantasies float here and yon.

Free from daytime and its heated blister.
Summertime breezing gentle coolness imbued.
Smoothly swimming in the evening zephyr.
One white duck drifts, enjoying solitude.

Ducklings snuggling in their island nest
Remember dipping for fish all day long.
Quietly cuddling, tucked in; they rest.
Deftly protected, safe where they belong.

Visions of swimming lined up behind mom.
Dance in their thoughts as they rest up for dawn.
Elegantly gliding in the silent calm,
Whiteness reminisces days bygone.

Ghost in the Woods

Paine's Prairie, beautiful, fair.
Open and free to God's breeze.
She, with her loved one walked there.
Sauntering, pausing, and pleased.

Oh, how the quiet stillness
Evoked the spirit within.
Fantasy merged with realness
Imagination did lend.

Basking, its vastness with sun,
Visiting onlookers dreamed.
Visualizing ancient runs.
Alive, where emptiness seemed.

Then, came the moment of truth.
Captured behind the great tree.
Visiting passers aloof.
Spirits the camera did see.

Glacial

Glacial torrents
Immobilized amid rocks.
Polar-waterfall.

Sunlight sparkles ice.
Artic White butterflies dance.
Wafting on the wind.

Glittery Swallowtail

Flickering brightness darting tree-to-tree
The giant swallowtail flutters lightly.
A message sent from God, for man to see.
That life has phases each one meant to be.

This lovely butterfly was sent to me
Now, I reflect upon eternity.
Pondering great thoughts hope can see.
Resurrected life is reality.

Does the egg stage represent life before Earth?
Did spirit selves live with Father before birth?
Did they await mortal life's physical girth?
How does the testing of each soul bring mirth?

Did the war in Heaven ring the battle sound?
Did the winners gain a prize… body bound?
Were losers' spirits cast to earth to confound?
And is this why, our life goes round and round?

The larval stage begins a waiting game.
Genetic codes would never be the same.
Does life in spirit form somewhere remain?
Oh God, waiting mortal birth until... shame.

Each chrysalis to me represents a lifetime.
Hoping to recognize eternal rhyme.
Born to earth to be tested for a time.
Praying to our Father for life sublime.

Human life flies here in Earth's cocoon,
Spirits age; death morns; souls swoon.
Mortality delivers freedom; souls croon.
And like a butterfly returns home, soon.

God and Black Rocks

PART1: NATURE'S SORROW

Dreary vapory
Fog encompasses blackness.
Stark stones drink sadness.
Water embraces.
Mourning the rock-strewn seashore.
Ghastly memories.

Sorrow waves bleakly.
Distant wetness, yellowing,
Sallow sentinels.
Weeping seashores plea.
Rhythmically requesting seas—
Lost antiquity.

(Mysteries once known,
History discretely filed.
Black sepulchers... groan.)

Part 2: MAN ENTERS

Man searches shadows,
Hidden knowledge locked in stones.
Conceived in theories.
Soothing conjectures.
Logical explanations
Many dismissed God.

PART 3: REVELATIONS

Truths have been unwound!
Once locked mysteries abound.
Majesty surrounds.
God created all—
Atoms, dark stones, rhythmic seas.
Our Universe, all!

(Black Bejeweling Sea
Breathing oceanic mists
God and Black rocks see—)

God and Mother Nature

The rain falls.
The strong and the weak
Both benefit…
God serves gardens
Seeds have been planted
By man and bird alike.
Wise whistling winds
Work within the rain
Pruning, removing branches
Rectifying trees.
Altogether connected
Designed in harmony,
Destined to recycle and renew
Man views and some men know…
God loves creatures and man.
His wonderful Mother Nature
Serves Him… and man.

God Encoded Life

God Created dry-particles,
Then, made DNA.
Encoding all life.
Later, when the time was right,
He formed all living things
Life on planet Earth thrives (thrived).

God: Good Gifts Ransacked

God watches waste and plundering
Gifts he bestowed carelessly demolished
Tragedy traverses fleeing creatures.
Pillaging a paradise unto destruction.
Temperaments become stone.
"Replenish." God said to man.
But too many ransacked instead.

God, Nature, and Me

Just a few years back,
Alone in my hide-away,
A hurricane track
Ever growing strayed.

As winds grew stronger
I called upon God.
Fear stayed no longer
Rain was soaking sod.

Pine trees gave a bow.
Falling limbs flew far.
Safe; I don't know how.
God's love shone afar.

The winds' speed increased.
As, I hunkered down.
Hurricane ne'er ceased.
It's raging around.

The windows whistled.
Many ghostly sounds
Fears hadn't drizzled.
Rain drops falling down.

Good Morning, Earth

Daylight arrives before my heart is shared.
But breaths of nature call me with fresh air.
Imagined gardens realities shall make.
Labors sweet success submits as souls quake.
Thus, dawning calls me to this day's affair.

Soft silver slivers silhouette the trees.
The new horizon peaks through trunks; it sees.
And I with garden shoes and shovel leave.
That quite place, where thoughts and dreams conceive,
Shall lead the way back here to write and gleam.

Muted pinky-orange ricochets… rallies.
Now, rush I to my gardens; my soul flees.
Before day's brightness signals summer heat.
New plants, spring forth; life missing not one beat.
For in the dirt alive are mysteries.

Man, and all of life thrives on "Mother Earth"
Remember, conservation has great worth.
Revealed by subtle whispers to the heart.
And prayers that ring before each new day's start.
Replenishing God's interlocking mirth.

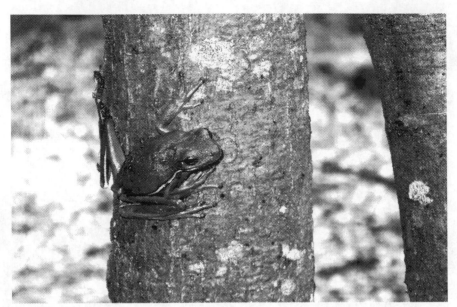

Tree Frog Clinging By Dane Smith-Johnsen

Great Tree Climber

High in a tree,
A small boy proclaimed,
"I am a tree frog"

Green Prince

The young prince
Could not be found.
Green tree frog?

Green Tree Frog

Little boys love green tree frogs.
Whether soaking in the sun
Or hoping from log to log,
Their slimy friend brings them fun!

Hop! Hop! Hop! The great escape!
Hearts pounding, the chase begins.
Jumping across the landscape.
One frog followed by big grins.

Leaves crunch underneath fast feet.
Tiny hands grab; two laughing.
Green tree frog plans his retreat.
Sparkles in eyes gleam, beaming.

Outstretched hands and one big lunge
The frog paused for the taking.
But ready for the challenge,
He leaps while they are running.

High in a tree out of reach,
He looks down and starts croaking.
Leave me alone; I beseech.
Happily singing, clinging—

Gunshot Saguaro

Long spines. Waxy skin.
Wounds within your flesh abide.
Tall… distinguished… cried.\

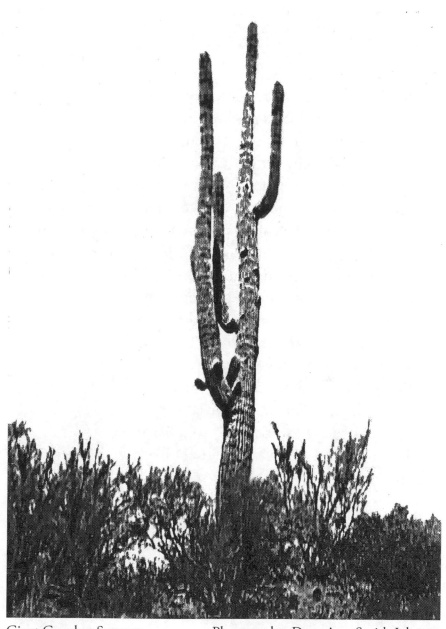

Giant Gunshot Saguaro Photographer Dane Ann Smith-Johnsen

Haiti: Beneath the Sun

Our "Mother Earth" has filled her graves; dread stays.
Entrapping thousands in her hungry jaws.
She quivered with her deepest rage, oh, day.
And from her belly under seas roars cause.
Spitting fire, destroying, homes; thus stealing breath.
Disaster bound its heart to tears affright.
Rescuers search the rubbles heaped with… Death.
She killed the young and old with just one bite.
Gone; children ripped from parents while they played.
And Old folks lost in thought found not their stay.
In moments those that lived had passed away.
Now destitute, survivors to God pray.
The rich and poor together work, none tire.
Will hopes and prayers revive their stolen days?
The rescued, shocked, and dazed reap horrors', ire.
Life lost beneath debris turns to a blaze.
The world looks on with wonder, all amazed.
Resilient, pained, some brave survivors' fight.
For tragedy had thrust death's dreadful phase.
But human strengths arose to face their plight.
As help from other lands aid dreams betrayed.
Reminding all who lived that we are one.
United humans, tasting dread; strength stayed.
Compassion, peace, and love beneath the sun.

Hoot! Hoot! She's Afraid of the Dark

"Hoot! Hoot!" said the wise old owl at midnight.
The full moon shone its light throughout the trees.
Not afraid of the dark why the bright light?

Come quick, my sons, look. Darkness is her fright.
Before, as a child shadows made her freeze.
"Hoot! Hoot!" said the wise old owl at midnight.

She's hiding under covers; see this sight.
Do you want to make her jump? Go there; sneeze.
Not afraid of the dark why the bright light?

If afraid when you are young, it's all right.
But for goodness sakes for a lifetime, please!
"Hoot! Hoot!" said the wise old owl at midnight.

Fly over here my sons to higher heights.
Watch her. She's afraid of nights' whistling breeze.
Not afraid of the dark why the bright light?

If you ask her, she'll deny her fears' might.
Sometimes, I hoot right near her, just to tease
"Hoot! Hoot!" said the wise old owl at midnight.
Not afraid of the dark why the bright light?

Holy Harvest

Dreadful suffering came with sin.
Defiance brought the serpent's goad.
Harvest fields did then begin.
Man was wrought beneath the load.

Passion brought good gifts from God.
Gardeners tend to flowers young.
Full of hope, they till the sod.
A brand new harvest has begun.

Bounty blesses; God bestowed.
Holiness entwined within.
Perfect love overflows.
Lovely gardens grow again.

Hopeful Manatees

Beneath propellers lies disaster,
Hopeful manatees nurse their young.
The froth and wake coming faster
Beneath the river lies disaster.
Swimming slowly, praying, Master
Save us from this boat is sung.
Beneath the river lies disaster,
Hopeful manatees nurse their young.

Hunter-Gatherers

Hunter-gatherers walked the earth.
While finding food and giving birth.
Welcoming caves became their berth.
Each man knew what life was worth.

Man was creative and used tools.
At times he lived the Golden rule.
But then, like now, there were some fools.
And sometimes men were very cruel.

Arrows and rifles lacking love.
Distressed our Father up above.
Hatred fit haters like a glove.
There was no sign of peace… just shoves.

Slaughter brought a nation malaise.
Ancestors mourned for olden days.
When bold and brave the bison grazed.
And golden fields glowed sunshine's rays.

Years ago humans tilled the soil.
Never drilled for or thought of oil.
They spent their days with diverse toil.
Struggled to live without turmoil.

Modern man must soon realize.
Perpetuation now applies
Man and nature must harmonize.
Replenish, as God's did advise.

If Only Trees Could Talk

If only trees could talk there'd be so many things to learn.
Old tales we'd hear of sweethearts that beneath their shade
 had kissed.
Oh, lovely sights of nature that they saw before their fall.
We'd hear of nearby habitats where snakes and possums hissed.
We'd know how careless ravaging harms: Deer. Baboons.
 Raccoons.
The Elephants, gazelles, and mice would seek the trees' advice.
And bears that sleep in wintertime could hear about the cold.
Listening to great wisdom from the trees would be quite nice!

And if the tree was old enough or passed along life's tales,
Perhaps we'd see another view of slaves in history.
The trees with years of wisdom could upon us shed some light.
Then, man's impact upon the earth would not be mystery.

Take Joseph serving Potiphar accused; that changed his life.
The king could ask a nearby tree and behead the lying wife.
Let's go a little further back, the serpent's words to Eve.
He, twisting truth among the leaves, Eve might not have
 believed.

If only trees could talk, we might protect them differently.
Replenishing along the way, learned wisdom as our mark.
Would we embrace the kindness every living thing deserves?
Or would we cut our name into its life beneath tree's bark?

Kansas Hill

Years ago in Kansas on a hill near Tuttle Creek,
There was a lovely pasture with some fir trees and some sheep.
I loved to walk along the road and sing to butterflies.
We never had mosquitoes; there were lots of dragonflies.
I had a book of flowers that I took on many walks.
The neighbor's dog would come along; we'd have some little
 talks.
While strolling on that Midwest trail, my heart was filled
 with love.
God walked close beside me as I thought about life above.
Just Him and me along that road beneath His bright blue
 skies,
I pondered many good days while I walked that country
 road.
Sometimes I'd even sing a prayer to show how much I cared.
The sheep and me were not alone; we meet God on that hill.
And so it is when I look back upon the signs of spring.
I thank my God that He was near to hear my needing sing.

Katrina

Katrina whirled
And mapped the route
Across the seas
Her battle shout,

The river surged
No longer tame.
The dams grew weak.
Not much remained.

The floodgates failed
And Hell rushed out.
The scrambling souls
Groped all about.

Dreadful horror,
Now come the cries.
Children are lost.
And parents die.

Those so adored
Are filled with grief.
The world stands by
Oh, disbelief.

The winds dealt death.
The gamble lost.
Where lies the blame?
Who bears the cost?

Destruction crept.
It's harvest reaped.
The howling winds
Taunt no relief.

But fellow man
And God's good grace
Eases the pain
The living face—

Leaves

Falling leaves deliver warmth
Blanketing the Earth each year.
Winter speaks in frozen voice.
Creatures shiver, snuggle, and fear.
Then, a breath of fresh air… ah!
Established long ago…
Deciduous and evergreens
In the beginning… by God!

Life of Vines

Life entwined as one
Unwittingly suffocates
Eventually—

Life: Golden Strikes

Golden-orange striking.
Thunderclouds hurling echoes
Warn the silent sun.

Lightning, "Not today." And I Live

I should like to die upon a mountain,
Standing, my face gazing upward to God.
Struck by lightning, when asked, I said.
Then everyone will know it was God's rod!

Every time a storm cloud drifts overhead.
And the weather reports predicts lightning
I think about God. "Not today." He said.
I wait. And live another day, singing.

Many friends around me have died sleeping.
Most agree that is the most pleasant way.
No pain, nor agonizing suffering.
That would be easiest they all say.

Quietly sitting, watching movies… Pow!!!
Flashes of light filled the yard; none hit me!
A standing oak was ripped apart. Oh, wow.
Bark was gone on one side of a pine tree.

Each time there is a storm cloud overhead.
And thunder prances around the lightning
I think about God. "Not today." He said.
I wait. And live another day, singing.

Love Bugs

When I see the love-bugs fly,
Drifting here and there.
Suddenly, I realize—
Love is in the air.

(Love to hold long past old.
Love to mold, pure as gold.)

Hovering hope landing near
Loyalty, my dear—
Floating true beneath the trees.
My love to thee seals we.

Lightly floating on the breeze
Anywhere dreams please.
Knowing now just where to land,
Hoping plans stay grand.

Mermaids

Her myth long lived among yon sailors.
Belief she is… lingers not nigh.
Her beauty brought shining sabers.
Her myth long lived among yon sailors.
Imaginings became their jailor.
Now, manatees, the myths belie.
Her myth long lived among yon sailors.
Belief she is, lingers not nigh.

Mid-Ocean Ridge

Crust and mantle meet
The ridge spreads beneath steal gray.
Flaming fire sees.

Mingled Creation Flurries

Oh how lovely are the trees.
Proffers man, fresh air bequeathed.
Recycles breathes; life receives.
Interactions God conceived.

Leafless branches endure freeze.
Anticipating buds reprieved.
Spring esteems flower frenzies.
Interactions God conceived.

Summer welcomes gentle breeze.
Hot… frolicking often bereaved,
Wafting winds cool, rustle leaves.
Interactions God conceived.

Hurricanes blow prune and preen.
Fallen limbs… homes… food… achieved.
Rainfall rinses; green plants sheen.
Interactions God conceived.

Oh how lovely are the trees.
Intricate plans live achieved.
Mingled… creation… flurries.
Interactions God conceived.

More Honey?

There once was a girl who liked honey.
When robbing beehives she looked funny.
She climbed every tree
Where a hive she did see.
But the bees stung her hide… no more honey!

Morning Mesmerizes

Pastel painted skies
Mirrored heavens suffusing,
Silent reflections.

Morning Sounds

Silhouetted trees.
Silver morning skies caress.
Crickets and frogs stop.

Morning Treasures

A hint of golden sun; a treetop glows.
One brown leaf floats slowly toward the ground.
Autumn, not yet arrived, stretches her wings.
Sunshine beaming beyond dense trees glows bright.
Thus giving just a glimpse of life beyond woods.
Reflections of a busy past recalled.
Gratitude rises through the clouds to God.
All-knowing wisdom brought me to this peace.
Tranquil reflections and life with love merge.
As morning awakens, anticipation hopes.
And sorrows that have borne pain dissipate.
Armed with joy, sorrow no longer has a grip.
The morning light heightened brightens life's view.
Optimism is born. Each day is new.
And at dusk, I shall say adieu, adieu.

Mosquitoes Chased Us

Two people in the Everglades pitched tent.
Where summer heat refused to relent.
Picnicking at dusk.
Mosquitoes and us—
We were saved by our race to the tent.

Mother Earth Weakens

Mother Earth weakens.
Bearing the weight of the world.
Blemished and flawed by man.

Mother Earth

Planet Earth born.
Mother Earth remembers well.
Even now, she quakes.
Heavens. Earth. And skies.
Converged during creation.
Singing joyful songs.
And pale cobalt blue,
Orchestrated the concerto.
While soft white descended.
Sunlight goes bluing.
And the mountain ridge glistens,
That life may be full.
Trees in the valley,
Reach for God's pale cobalt skies.
And hope for more rain.
Not long ago quenched.
She again begs, "One more drink!"
Skies send gentle rains.
While clouds and sunlight
Fluff upon the refreshed ridge.
Plants imbibe fresh dew.
In Mother Earth's womb,
Every living thing was formed.
All the earth shimmers

Mother Nature is God's Friend

Mother Nature, earth's treasure,
Has, since the first dawn, served God.
She proclaims beauty.
From earth's original mud
Through man's visit to the moon
Even the future
All placed in her loving arms.
She caresses existence.
She does God's bidding.

The natural world is hers.
Her beauty was reflected.
In the beginning
Upon primordial seas
Like a butterfly's cocoon,
She has protected.

Mother Oak

Mother Oak, majestic and motionless.
Standing stately and breezeless on this morn.
Fragrant autumn day announces coolness.
Joy flutters in the heart greeting life born.

A single leaf glistens reflected beams.
The rising sun captures lives' flickering
Newness summons curious friends, it seems.
A fuzzy gray tail behind leaves, hiding.

Uplifting glimpses in the morning show.
One more gift from God honors my window
Worries' downward slip can no longer grow.
The light of lights, my Lord, thus gifts bestow.

And when life's deepest darkest days impinge,
Nature's gifts live there beyond fears and fates.
Stolen glimpses beyond the curtain's fringe
Precious gifts abide as God, for me waits.

Sun Kissed Oak Tree Photographer Dane Smith-Johnsen

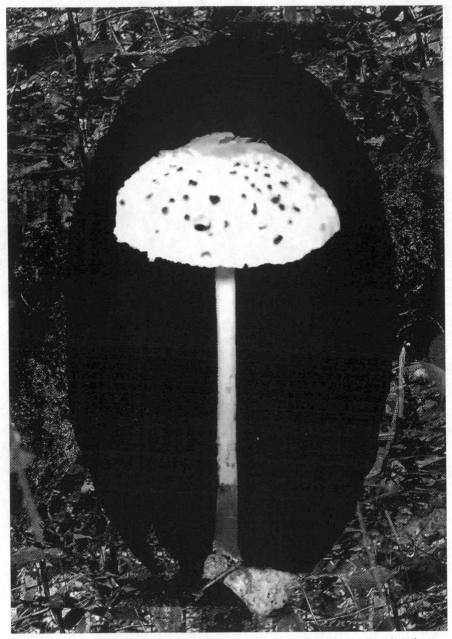

"Angel of Death" Fungi　　　　　　　Photographer Dane Smith-Johnsen

Mushrooms and Death

Mushrooms are fungi that come in many beautiful colors.

Unfortunately, some of them are deadly poisonous.

Some of the deadly mushrooms are similar to edible ones.

Horrible tragedies occur when misidentified mushrooms are eaten.

Rather than eat them, take pictures; leave them to do their job.

Observing and photographing the many colorful species can be exciting.

Organizations exist that sponsor mushroom hunts.

Many people eat only mushrooms from the grocery store.

Safety First: never collect and eat mushrooms unless an expert says, "OK"

My Garden

A fairy came to my garden today.
Dreamy, wispy, whisperings to my dismay
Elegant, words flowing like liquid moon.
Fantastically zooming across my gloom.

Pirouetting between wildflowers, weeds.
Between each breeze, she scattered lovely seeds.
Sipping sweet dewdrops, dancing time away.
Loomed byways where a thought could loose its stay.

Reason waits and begs, impatiently… lost
Each ounce of which sense savors at all cost.
While fantasy lives on, I dreamed her there.
And long to fly beside her to somewhere.

Alas, all day, I watched her lovely flair.
Knowing full well my garden she did share.

Nature's Frieze

Deciduous leaves
Borne scarlet and harvest gold.
Adorning beauty.
High above the trees,
The silvery-white sky glows.
Oh, peaceful, pretty.
Autumn colonnade;
Awaiting winter's bright snow.
And golden lights freeze.
Clinging leaves release.
Naked branches, winter's cold.
Autumn's blanket lay.
Soon, an icy freeze
Comes to seize its deadly toll.
Life, protected, stays.
Nearby, colors fade.
Shine on, glassy pond below.
Visually tease.
Nature's painted frieze
The blessing an artist knows
Nearby. Reflecting.

Nature Primps

Mother nature primps.
Reflects her skies in the lake,
Remembers springtime.
Asceticism—
Mother Nature's cleverness.
Evergreen schisms.
Newness in the air,
First sign that spring dares.
Buds showing on stems
Silent stillness calls—
Winter feelings concluding
Springtime greets us all

Nature's Songs

Songbirds retire.
Sunshine submits to darkness.
Gradually graying.

The loon's haunting wail
Floats across evening's dusk
Proclaiming presence.

Furry scampering.
Squirrels scurry to their nests.
Chattering sweetly.

Crickets hind legs hum.
"The seduction spectacle,"
Lovers come hopping.

Diamond studded skies.
Frogs croon midnight serenades.
And kiss princesses.

The night's music spent.
Awaken hear the roosters
Crowing the clocks' song.

Nature's Night Sounds

Relaxed and Tranquil
The still of the night intrigues.
Creatures of the dark liven.
Serenades commence.
Frogs crone 'til their heart's content.
"er-ah-ah, er-ah-ah, croaks.
Soon, crickets' join in.
Their high-pitched, humming begins.
Filling the night with music.
People are snoring.
The distant owl says, "Hoot-hoot"
A game-hen roosts in silence.
She is safe for now.
Far away calls resonate.
Loud, over the crickets' hum.
"A-h-o-o-o-o-o-w. arrh, arrh, arrh,"
A coyote? A wolf? What?
Shrillness fills the cool night air.
"A-h-o-o-o-o-o-w. arrh, arrh, arh,"
Over and over, she calls.
The eeriness lingers on.
Oh, nocturnal sounds.
She closes her eyes to rest.
Crickets sound, the lullaby.
All is well for now.
But before her twilight sleep.
A scampering sound is heard.
Oh, what might that be?
Toenails tapping on the ground,

Herald a soft squeak, squeak, squeak.
Licking chops, a mouse!
Crickets sing on until dawn.
Rubbing hind legs together,
They hum nature's songs.
Rustling leaves in a cool breeze
Glisten at the rising sun.
Roosters' crow proudly.
A snake slithers beneath leaves.
It stops, coils up and rattles.
The birds squawk, "Danger!
Loud not-blending screeching sounds.
Defending, the birds zoom down.
Frantic together.
They dive-bomb to frighten him.
And angry chirps fill the woods.

Above slithering.
When the snake has disappeared,
Quiet finds its place again.
-In its forest home.
The birds resume their singing.
Falling water splashes rocks.
All is well for now.
Young squirrels come out to frolic.
And they soar from limb to limb.
Cats meow. Dogs bark.
Dead branches crash to the ground.
Deer antlers click on the trees.
And people wake up.

Natures' Nostalgia

Class 4 hurricane is inward bound!
It's out at sea, but will be aground.
Standing in wind, reporters expound.
Residents scurry; their fears confound.

Silent birds in nests stay homeward bound.
Bravely, furry creatures hunker down.
The rushing wind screams its loudest sound.
As furious rainfalls flood, astound.

Windows whistle as the trees bow down.
Thunder bellows a deep, heavy sound.
Flashing, dashing lightning hits the ground.
And wind contorts as it speeds around.

All the pruned branches fall to the ground.
Habitats made from their falling down.
Thirsty rivers drink the rain inbound.
Implicit wisdom becomes profound.

Ode to the Prickly Pear

Oh, succulent delight in the sun basking.
Life giving juices battle the heat, unseen.
Stately preserved, awaits time for the asking.

Dazzling, sweet taste tantalizingly pristine.
Unpretentiously tempting for skilled, foraging.
Boasting yellow flowers bring forth nature's cuisine.

O prickly pear, thy blossom in deserts, gleaming.
Stalwartly protecting, needles guard by the score.
Defending sentinels, heritage reflecting.

Standing through history like an artist's centaur,
Your time-honored values speak in Indian code.
About brews, live fences, sweeteners and folklore.

Medical remedies in your flesh find abode.
Cosmetics. Cool dyes. Pharmaceutical babble—
I wonder, do some think that you became a toad?

Not I! So, we shall stick to that which is factual.
Cactus jelly tastes great, a fact that is actual!

Oh, Lipstick Plant

Oh lipstick plant with your bright shiny leaves.
Your beauty decorates with shades of red.
Plant debris lands in crevices of trees.
And there you live, while by rain and air fed.

Lance shaped green alternates along your stems.
Colorful blooms, a red-coral delight,
Burst forth, nature's secrets, revealed to men.
Your awe and glory grows beneath shade's light.

Harmless to nature and helpful to man
Picture the war paint on faces of yore.
Decorations decked by the potter's hand.
While vogue, women adorned lips, and much more.

Warding off evil, old soul reliever.
You bestowed unto man, reasons to shout!
Whether used to cure ailments or fever.
Your sacrificed parts clearly helped man out

So, while you are living up there in trees,
And a summer breeze cools the hottest days.
Man proclaims, "Thank you with you we are pleased."
Pose in your beauty uplifting man's ways.

Ominous Tobacco Plants

Life emerges,
Like a silent cigarette,
Pre-ordained to kill.

One Mother Earth

Mother Earth reclined.
Bearing the weight of the world.
Relaxed and wanting—

One Stallion!

There once was an appaloosa named, "Spot."
On his white rump was one very big dot.
Needing more room to roam.
He found himself a new home.
To his harem in the desert, he's hot!!!

One Cool Caterpillar

An orange caterpillar
Graced the road today.
Inching his fluffy body
Slowly going his way.

I know he sensed my presence.
But he did not even blink.
When he raised his head up high,
I swear I saw him wink.

I walked around in circles
And I kept an eye on him.
Then just before he nibbled,
I signaled to my friend.

Come see this caterpillar.
Marked like a tabby cat.
I never before had seen one.
He was fluffy and so fat.

She hurried right on over.
And brought her big dog, "Bear".
We three were bending, looking,
At that caterpillar there…

Big "Bear", with his face up close,
Took one deep sniff with flare.
"Orange-tabby" nonchalantly
Stuck his nose up in the air.

Paleontologist

With heart afloat and mysteries to solve.
They dig their way through rock and soil each day. Their
finds around obscurity revolve. Where dignity and strength
once knew earth's stay. The sun, when bright with noon
daylight, skins burn.

Persistently with shovels, picks and drills.

They work away in dirt where theories churn. And excavate
the past with well-honed skills. And all of this they do in
search of truth. Persistently for unfound facts they yearn.
They search the earth for clues about its youth. Forgetting
while they work, God made each turn.

Peach-blue Heavens

Peachy-blue heavens,
Decorate the horizons.
Warm waters ripple.

Perfectly Natural World

Man, wildlife, niches
Together linked upon Earth
Reciprocate life.

Plate Tectonics

Where crust and mantle
Meet beneath the steal gray seas,
Fiery flames burn... melt.

Psychosis

Psychotic white bird
Attacks a young black dawdler.
Be on the lookout.

Last seen at Hope Beach.
The smaller black bird still jailed
Inside egret's mouth-

Approach with caution.
The youngster goes on chirping.
Daring escape failed.

Egret demands fish.
Negotiations botched-up.
No hope is in sight.

Result is tragic.
Some things are hard to swallow.
But they keep trying.

Quiet Days Calm

Quiet summer days,
And lovely special places
Calms a lonely soul.

Rain

Rain
water
holds the key
to survival
for all life on earth.
They depend on mankind.
Wisdom and progressiveness
must prevail: safeguard, purify.
Our failure to do so means sure death.
Wildlife and we are endangered... Conserve.

Rainfall

Rainfall
Wet drops
Dripping delicious tears.
Gratifying, satisfying, revitalizing, heavenly

...*Raven*

A raven called the morning dawn.
Naught but eerie thoughts did spawn.
And while it crowed in darkest night,
It filled my soul with fearful bites.
It roamed around within my mind,
Trying to make sense of time.
But 'ere the sound did call again,
The suns arising brought its friend.
For light filled in beneath dark trees
And fear no longer seemed to be.
Thus, naught was lost and naught was gained.
Sounds that shrieked the dark again,
With God and daylight found amends.
Free from sins and full of grins.

Raven at Dawn Photographer Dane Smith-Johnsen

Armano the Auracano Rock Star Photographer Dane Smith-Johnsen

Rockin' Rooster

There was a rockin' rooster
He could whistle through his beak.
The hens thought he was chipper.
So, he'd peck them on the cheek.

His fame began to spread around.
Soon, every rooster knew.
That when they went to his hometown,
They could, "cock-a-doodle-do!"

Before too long he drew a crowd.
That singing-pecking chicken—
He liked to dance and crow real loud.
But he did not like finger-lickin'!

Armano is a special roo.
He loves to strut out in the street.
And that's not all he likes to do.
He likes to whistle to the beat.

Because he rocks his microphone,
Hens and chicks love him forever.
That is why when the singin's done,
They all peck his cheeks together.

Running With the Wild

It was back in the year 1963,
Among horses wild and free;—
Many manes and tails untamed by the breeze
Were seen dashing past dunes without trees.
And the horses remained under cobalt skies
Lacking fear of nature or man.
They were wanting and I was wanting.
To run freely on the land,
And we felt with a soul that was deeply honed.
I and those horses so free—
Understanding all between God and delight.
Dreaming and running, we.

Some cowboys, out there distantly riding,
Heedless of horses and me;—
Hot! Summer's season (as all men know,
In the desert sands out west.)
That the heat blazed down from the sun, burning
Soon sent sunburned riders away.
But our wanting was stronger by far than the heat.
That drove countless others away—
Seemingly much wiser than we-
But scorching rays from the heavens above,
Nor the desert lands without trees.
Could dissuade the wanting in me
Oh, dream of my ride filled with love.

Bareback, clutching his mane,
wind-songs running wildly sing
Of all dreams that were ever in me—
Not one was as lovely as this—
Reckoning the forces of reasons discourse.
Nor realities wisdom could see,
For never had ever my soul felt the force.
Of this wonderful unity, we:—

Now, the memories bring to heart wonderful
dreams.
Of oneness between horses and me;
And the thought never leaves but my dream
is retrieved.
Of the love given ride through the sands;
And so, all of my soul, reaches out in the
night
For the wanting and giving on the wind's
bareback flight.
In the desert when no one could see—
The appaloosa's bonded with me.

Rustling at Dawn

The morning light arises as tree silhouettes succumb.
To dance on the horizon where the morning sun has shone.
On lily pads the crooning frogs upon their banjos strum.
While crackling grass feels fawns awake before the wind has
 blown.
The scent of man pollutes the breeze as heart screams make
 them numb.
Soon, father swiftly disappears, the fawn are not alone.
Their mother bravely watches while the hunters pass that
 way.
Secluded by the thickest scrubs, three lives were spared that
 day.

Salt of the Earth!

When earth was frozen,
Without oceans and rivers,
Did God melt, with salt?
Oceans—

Ah! Ha!

Schaus Swallowtail

```
        *           *
    *                   S
      S           W
      C           A
      H           L
      A           L
      U           O
      S           W
      T
            *A*
```

We are * I * sadly...

Schaus Swallowtail * L * Schaus Swallowtail
Did you know that I have been in danger for twenty years or more?
There has been lost habitat galore! Hurricane Andrew hit, shattered.
Plant some key lime trees; help feed us. Keep us wafting on
the breeze in trees.
I love to munch on key lime and torchwood sometimes.
Help us stay alive. * Preserve! Enjoy!
Help us survive. * Plant host trees.
We are fine. * Sublime!!!
Flying backwards
Escaping! Predators
Save us! We are:

```
        D           D
        Y           Y
        I           I
        N           N
        G           G
```

Science and The Truth

Sun centered earth found man's curiosity.
Then, scientists tried explaining theories well.
The church defended faith contentiously.
Thinking the theory would most assuredly harm.
Patrons' faithful homage, and cause demise.
That's when they issued their stance before man.
Excommunication: solution of choice.

Round one began against Galileo
His scientific work severed him from church.
Science was thought the enemy of faith.
Then, came Copernicus sharing ideas around.
Hundreds of years have passed away since then.
But the contention still blooms in modern times.
When will hate end so truth can be known clearly?

A faithful few desire to know facts.
Are we not born in God's image and here dwell?
Now look up, heaven watches knowing all.
Fruitful members shall not fall away from God.
His truths and facts together always are.
God's words will never let one-person down.
We, in His image must ask to understand.

Snow on Obsidian

Obsidian Cliff
Caressed by heaven's white snow,
Chills and contrasts life.
Brightens earth's beauty
Ice melts; then, streams to the edge
Fresh. White. Innocent.
There, turbulent times,
Come crashing into stillness.
Violent waters fall.
And are soon absorbed.
Washed away quickly, gently
Like love on brisk nights.

Compare sweet virtue.
Pure love shared; your wedding night.
Preordained delight.
Abstinence 'til wed.
Rainbow colors shining bright.
Each day love is fresh.
Like snow on obsidian.
Virtue embraces the heart.
And melts into love.
Forever.

Soundless Reflections

Red earth, ancient rocks
A steel gray sky infusing
Soundless reflections.

Southern Autumn

Yellow sassafras.
Creeping Charlie's, golden orange
Southern autumns zing!

Sparkling

Shadows on the shore
Reflect pulsating beauty.
The sunshine shimmers.

Special Star

A special star in the sky shines bright.
It warms our days and cools our nights.

We spin on our axis; rotate around.
Because of this star, life on earth can be found.

It is an elite in our galaxy.
To scientists it still holds mystery.

Some think it was born in one great big bang.
I think God created and angels sang.

For eons past, earth has traveled in space.
Circling around the sun's bright smiling face.

Man's experiments discover a lot.
But God knows all things; men do not—

Spider Poem

I felt your web first.
It was attached to my face.
But I have escaped.

Tell me, "Do you bite?"
Your colors black and yellow
Frighten me away.

Banana Spider,
You have spun a perfect web.
And await your prey.

Silently, you watch,
Will a juicy morsel pass?
Oh, sad-deadly fate.

That is nature's way.
Here today, gone tomorrow.
Death feeds the living.

Banana Spider By Dane Smith-Johnsen

Gazing Globe By Dane Smith-Johnsen

Spirits Gazing into Heaven

The future may seem mysterious.
Sometimes mankind becomes curious.
Pondering, gazing into cloudy skies—
Wondering what tomorrow may bring.

Hoping to find answers.

The past may have had transgressions.
Some men have made confessions.
Gaining peace as nature soothes each day.
Praying that forgiveness comes their way.

Hoping to find answers.

The present might be very tedious.
But man might be victorious,
Seeking signs of love from God each day.
Gazing into Heaven inviting God to stay.

Hoping to find answers.

Then, alas, finding answers—
Not from the natural world.
But instead, from God's love.
Spirits gazing into heaven, knowing... hopes.

Splendid Summer Sun

Sun bursting brightly
Golden skies and perfect light
Makes hearts leap with awe.
Reflections glow clear.
Although clouds hide thy brilliance—
Dazzling rising sun.

Spoonbill Spooning

Roseate elegance
Pink lushness poses; invites.
Photographer awes.

Spring!

Every spring eggs appear in yards; it is **EASTER!**
Children fill baskets and eat chocolate **BUNNIES.**
God, through life and nature, shows His **LOVE.**
The first buds on sleepy trees join the **CELEBRATING**
New life begins, physical and spiritual; it is **SPRING!**

Spring Hocus Pocus

Hocus pocus springtime crocus.
Bring your glory into focus.
Strewing sparkles light has found.
Letting colors dance around.

Hocus pocus springtime focus.
Pray that predators eat the locust.
Reptiles, birds, mammals, too
Sometimes, man will eat a few.

Say the words together, please.
Hocus pocus save our leaves.
Flowers near tease allergies.
But springtime beauty is worth the sneeze.

Spry Spring Thief

Squirrelly little thief,
Thought the Hummingbird feeder
Was one swinging drink!

Sumacs and Citrus Breeze

Sumacs at the woodland's edge flaunt bright colors.
Sassafras trees, leaves shimmer, dappled golden red.
Creeping Charlie paints the forest floor auburn.

Hidden food, fallen pecans, acorns and such
Happily gathered by scampering squirrels.
Amassing extra stores for this winter's hoard.

Falling leaves blanket the chilling earth with warmth.
Dancing crisply upon gentle puffs of wind
Silent, dormant, crunches beneath roaming feet.

Wildlife snuggles warmly in dens and niches.
Tadpoles metamorphosed hop to earthen warmth
Speckled fawns nuzzle at their mother's teats.

Mom's Afghans assume their traditional place
Awaiting autumn snuggles and cooler nights
Gathered wood behind the house anticipates.

Returning coolness defies the summer's heat.
Stately scented pines enliven pending chills.
Fresh! Breezy! Citrus fragrance. Southern autumn.

Summertime ABC

Apple blossoms scent the air.
Bluebells shows off soft hues.
Carnation red grows vibrant.
Delight; summer views.
Elephant ears hear laughter.
Frolicking springs nearby.
Grandchildren run, playing.
Heralding the sky.
Imaginary clouds puffy shapes.
Jesting with the sun.
Kissing goodbye to snowflakes.
Looking forward to summer fun.
Merriment begins; hearts chuckle.
Nice vacations planned.
Opulent colors sparkle.
Playing in the sand.
Quarter horses trot along.
Rodeo cowboys tossed fall down.
Smiles around the campfire ring.
Trolley rides exploring town.
Underneath the clear blue, singing.
Vacationing from state to state.
Winding along dusty trails.
X-treme enjoyment cannot wait.
Yippee! Happiness prevails!
Zinging over hills and dales.

Sun

Reflections glow clear.
Although clouds hide thy brilliance—
Dazzling rising sun.

Sunset

When the sun falls to the horizon.
A sea of colors calls the night sky.
Clouds reflect golden hues and bright red.
Masterfully clinging to dusk.
A sea of colors calls the night sky.
The sun sings goodbye blue horizon.
Masterfully clinging to dusk.
Splashing colorful farewells once more.
The sun sings goodbye blue horizon
Clouds reflect golden hues and bright red.
Splashing colorful farewells once more.
When the sun falls to the horizon.

Sunshine Trickles

Morning sunshine trickles light to the leaves.
Darkness grieves, oh, night.
Dawn awakens daylight.

Suppressing

Some flowers dream of watching moonbeams,
From darkest night until the dawn…
It matters not how bright each day seems.
Some flowers dream of watching moonbeams,
Shutting out hope ignoring life themes.
Suppressing truths of struggles gone.
Some flowers dream of watching moonbeams,
From darkest night until the dawn…

Tell Me Why...

Ecosystems live.
Biodiversity thrives.
Where... man is least found.

The Daisy That Cried

There once was a daisy that cried.
Her best friend was battered and fried.
The big man that ate her
Was lain in a coffer.
Insecticide was the reason he died—

The Dawn

Shall we greet the dawn?
And go wandering amid.
Flower fields and fawn.

Where joys delight… stay.
Warmed by each golden morning.
Tingled by loves ray.

Together being
Breathing star bejeweled darkness.
Passions hopes, teeming.

Dreaming with my flock.
Fantasies born in heaven
Humming music… Bach.

Come, my dear, and rest
Entwined until first daylight.
Love having been blessed.

The Dust of the Earth

God created dry
Microscopic particles,
(The dust of the earth.)
From which first DNA strands
And every single atom
In our universe were made.

The Empty Conch

Gentle water's edge,
Teaming with living creatures,
Oh, so serene.
Foam fills thy shoreline.
And tides pulsate to and fro.
Pretty silver day.
Sharp jagged rocks wait.
Neither man nor creature walks.
There, is amity.
Where? It's there, beyond
The gate to exploration,
Inquisitiveness.
Can you hear it call?
Listen to the sleepy shoreline.
Gaze beyond the trees.
Thy curvy walk breaks.
And has so done for eons.

The dinosaurs know.
Fearfully, they lived.
And walked jagged coral stones.
There was no gate, then.
Now, it stands open.
And invites each weary soul.
Come; enjoy my peace.
Here, is happiness.
Stand-alone. Be full of God.
Fear not; He is near.
Let waters cleanse you.
Stroll along the bending shore.
Listen, Oh, listen.
Pulsating tides call.
Thrive, before the gate closes.
Life beats in the conch.

The Feast in the Glen

The meadow in the glen lies far below.
Where brightly verdant pastures feed the elk.
And noonday warmth is heightened by sun's glow.
Where mother's feed young calves their fill of milk.
On tranquil afternoons, there, breezes blow.
And wildlife lives in safety with peer elks.
At times, without intrusion man can peek.
And gaze at grazing creatures strong and sleek.

The Field Where Wheat Grew Gold

She wandered through the field where wheat grew gold.
Love's passion held its flame, for suitors dreamed.
She wrestled in the grain with love untold.
Wind wafted the golden waves where she daydreamed.

In skies above the sun was shining bright.
The clouds in magic colors stole her trance.
Her heart with glee imagined lovers' night.
Her fantasy bejeweled the field, she danced.

Soon, reverie enslaved her very thought.
With joy of soul she twirled among the grains.
For love thus dreamed, reality has not.
Delight and songs, like him, she dreams again.

The Florist

She cuts her pretty flowers—fresh each night!
Fragrance, bright and flowing;
Fall's new blossoms flourishing
Fresh bouquets, love flowering.

The Food Chain

Bug with the munchies
Chomps while butterfly distracts.
A bird swoops down! Yum!

The Grateful Gardener

Beneficial bugs
Buzzing and helping each day,
Protect; pollinate.

The Greenhouse Effect

Thirsty, parched earth weeps
Scorched cracks greet the burning sun—
The end waits bereaved.

The Heart Stays

Morning Glory cuddled high in the oak.
Your bright lavender enlivened my heart,
Fear and pain overwhelmed; a dreaded yoke.
Then, God, outside my window, love starts.

Verdant! Vine winds upon the gray-brown bark.
High above the unexpected is found.
Cascading like a bride's bouquet, please hark!
Beauty was God's simple gift yet profound.

Knowing, when all seems hopeless, even love.
hat Heavenly Father knows how to give.
The simple things in life, gifts from above,
Like today's Morning Glories, that there live.

Tomorrow borne of sorrow, life may be.
Today, the darkest hour fades away.
Beyond the fear of death that one may see.
God lends a hand uplifting; the heart stays.

The Miracle: Genetics and the Future

God organized all genes with specific codes.
Scientists are studying and mapping out the codes.
The more man learns about genetic orderliness,
The greater my faith in God's All-Knowing becomes.
Just think, when the resurrection begins,
And our body and spirit must reunite as living souls,
God can restore us, genetically—
We can be re-formed without losing one hair.
Why? Because that's the way genes are.
They carry the formula to exactly duplicate a creature.

Now, mankind understands the science of genetics.
Long ago, resurrected bodies seemed a mystery.
But genetics sheds new light on The Resurrection.
Anciently, God spoke of mysterious things
Man is now discovering new clues.
Thus, gaining understanding about the "How?" of things.
Mankind can now logically believe that God Created.
And surmise how God made Eve for Adam.
No magic was needed. God grew science.
God engineered genes he had already made.
Genes from Adam's rib were re-organized.
And God for Adam made Eve.
Does this sound Whacko! Quacko!
It is not; God and His sciences are real.
He is not a magician. But He knows a lot!
He knows more than we could in this life learn.
Certainly, one can now think that God is.

The Morning Surprise

Just as dawn turned blackness to gray,
The awakening world begins its array.
Sparsely heard chirping pierces the air.
Photographers wait; nature wakes there.

Quietly creeping while walking along.
High in a tree rings a bird's song.
Cameras snap and click the world.
Hidden in a bush a raccoon is curled.

It was Rosette Spoonbills season.
Picture the photographers' reason.
Awake before dawn awaiting their flight.
Ready at daybreak for stunning sights.

It was still too dark; we strolled… behooved
Suddenly, silently something moved.
The morning surprise was, to my delight,
A night heron hid out of fright.

Very slowly with camera placed.
Two or three clicks began the race.
Photographers ran to see what I saw.
The light was dim; they watched in awe.

The Mountain Watched in Awe

The wind whirled its singing sounds across the mountain range.
Zephyr and rain in concert sang nature's serenade.
Fire in the valley below tasted raging winds.
Earth saw all the awfulness, and begged, "Please let this end."
Fire looked the other way and ravaged the paths below.
Molten metal beneath the soil smelt the way to go.
Lava boiled in the mountaintops; singing changed to strife
Trembling creatures fled the place and raced the wind for life.
Water hearing pleas and rage, never a drop did send.
Rubble burned beneath the breeze and earth found no amend.
The mountains watched and tearfully asked," Have we no friend?"
Only God could save them then; please do, said they. Amen.
'Mid mountain's soul, fire's cost, and endless screams of pain
Earth recognized the tinkling tune of mid-summer's rains.
Giving wrap to wind's deadly sneeze and earth's dreadful glow.
Trickling drops of hopefulness drummed song on rocks below.
The mountain watched in awe.

The Night of the Snake

The decision was made.
About life's escapade
Live in woods unafraid.

Brave in the silent dark.
The dog began to bark.
My ears perked up, oh hark.

A rattle sound was near.
My heart shook with sheer fear.
And fright brought on a tear.

My whole body did shake.
Frozen, in bed, awake.
What would this reptile take?

My life was in danger.
There's no forest ranger!
Bizarre thoughts became stranger.

My scream and shout it seems.
Awoke me from this dream.
And then, my eyes did gleam.

The Rabbit Hunt

It was hunting day again. And rabbit was the menu.
I with my trusty single shot 22 headed down the lane.
Quietly, creeping carefully so as not to make a sound.
Looking, watching, pausing, hoping, wanting game.

Stepping over twigs, scouring the landscape with eagle eyes.
But to my surprise, there was not a rabbit to be found.
Wild flower blossoms subdued the stark reality of the hunt.
Monarchs and Viceroys visited flowers without a sound.

Hungry, having had no meat for days, the hunt continued.
Many times before, I had walked this very way; today was different.
The rabbits that usually came out were hidden. The hunt subdued.
Finally, two gray ears appeared above a tuft of grass. Pow!

One straight headshot and the rabbit fell. Fried rabbit for
 dinner, yes!
Suddenly, from nowhere, bounding through the grass came
 that scraggly dog.
The dog from around the bend and as usual, we raced for
 the rabbit.
The competition began; winner takes all. Guess who was
 robbed.

The Silent Forest's Nightly Wait

The silent forest rests while predators lie in wait for ruffling
leaves.
Life giving oxygen and nocturnal bloom's fragrance
permeate dark nights.
Nature's fallen wood provides a feast as insects and
microbes eat dead trees.

Danger is lurking and unquenchable hunger ravages
freedom's flight.
Once again, the screech of an owl and the rabbit's squeal
break the silence.
Life giving oxygen and nocturnal bloom's fragrance
permeate dark nights.

An act of survival overtakes life, without shame. Violence.
Creeping silently, craftily, carefully death, in the moonlight
glitters.
Once again, the screech of an owl and the rabbit's squeal
break the silence.

Then death gives life that perpetuates the living cycle
 through God's critters.
No sounding alarm had echoed nor warning given dangers
 in the woods.
Creeping silently, craftily, carefully death, in the moonlight
 glitters.

Crawling insects, flying insects, many insects meet death in
 the pitcher plants' hoods.
Immobile, carnivore awaits trespassers' sacrifice to the living.
No sounding alarm had echoed nor warning given dangers
 in the woods.

God made living things interdependent for life's good and
 replenishing.
The silent forest rests while predators lie in wait for ruffling
 leaves.
Immobile, carnivore awaits trespassers' sacrifice to the living.
Nature's fallen wood provides a feast as insects and
 microbes eat dead trees.

Solemn Subduing

Man was ordained before his creation to subdue the earth.
A beautiful world and amazing scientific principles formed.
God's kaleidoscope of creatures came forth with global worth.
Microscopic plants and one-celled organisms performed.

The universe became as eons passed; the environment
 transformed.
Creatures suited for life were formed; biological conditions
 changed.
Life seemed cruel, rigorous, and impossible as earth
 reformed.
Bit by bit a delicate balance of nature steadfastly arranged.

Dinosaurs had been part of a macrobiotic natural plan.
Preceding man, preparing the land, a scene so grand.
Upon those prehistoric lands, balancing nature began.
The environment of necessity changed; dinosaurs lost stand.

Rejected from the Garden of Eden, comes environmental
 man!
Suddenly, a little meeker mankind's life grew bleaker.
Hunter-gatherers wandered, learned, forming man's clan.
Subduing and survival became a rigorous new life
 adventure.

Thus it has continued through generations; here we are.
Finely tuned and diverse creatures alive; subduing our earth.
Man rising above difficulty with intense fortitude, the star!
Heightened sensitivity, now crucial to continued mirth.

Ruthless destruction, a momentous progression, proceeds.
Environmental plundering is now a product of much greed.
Desire beyond survival, taking more than one may need.
But joyfulness grows through care and the beauty of God's
 seed.

The Tree and Life

Athena's gift to the Greeks
Where shattered spirits solace seek.
Beneath the spreading olive boughs
Oh, place where refuge proffers.

The fruitful trees, meadow grown
And silver chalice never known
Labors captured, women's groan
Becomes the peasant coffer.

Poor souls living day by day
Beseech that blessings come their way.
And, as five hundred years flew past,
Their precious labors offered.

Fruitful olives picked by hand.
Ladders rest in shimmering sand.
Festive hearts celebrate and sing.
Joyful sounds stifle dearth's sting.

Shattered souls seeking relief
Scarcely see the silvery leaf.
The helplessness is all too real.
Unending, poverty steals… Life, that is.
Thunder clapped its heavenly sounds.
Air and cleanness, together flew.

Fresh ions! Oxygen, rained down.
Showers in sheets rinsed plants; they grew.
The plan, cleansing nature for you!

Loose branches, dead trees fell to earth.
New homesteads brought squiggling worms.

Without much adieu, there was birth.
Replenishing life on good terms.
Rent free, in a niche, each day turns.

Life silently lay on mud's ground.
Enjoying such beauty, it seemed.
Born in the mud, swimming around,
Croakers, not yet croaking, redeemed
Mosquito eating tadpoles' dreamed

Skies brightened, flashing stormy light!
The shrillness of winds loudly wailed.
Steadfastly, calmness grew to fright.
Shivering, serenity sailed!
Impassioned tranquility failed.

New, lovely! Bright. Beautiful sight.
Gone was thunder's deafening roar
The sun came out and shone it's light.
Sparkling in the trees evermore.
Bountiful birds sang as before.

Trees Caress

Trees that live on shale
Send anchoring roots deeply
Caressing waters.

Tranquil Earth

Strong.
Winds.
Whistles.
Windows shake.
But when it's over,
The earth is tranquil and fragrant.

Treetops at Dawn

Deep verdant treetops
Silhouetted against silver skies.
Announce that morning dawning
Is about to come along.
The silence in the woodland
Shall soon begin to stir.
When, beauty and reality
Together, again, confer.

Treetops at Dawn By Dane Smith-Johnsen

Butterfly Ginger By Dane Smith-Johnsen

Twilight and Ginger

Butterfly Ginger with blossoms of white
Fragranced the air with a mellow delight,
Sweethearts held hands as they watched the moonlight.
Longing for love, counting stars at twilight.

Running and chasing… prolonging their day,
Neighborhood children laughed loudly in play.
Life with delight marched its evening parade.
Never was nightfall so sweetly arrayed.

Beautiful flower… innocence portrayed.
Showy at evening, bright whiteness displayed.
Fragrantly breathing two sweethearts are stayed.
Butterfly Ginger, with pureness relayed.

When the day ended, love silently prayed.
Bring sweet reality to this earthly charade.
Cleanses the soul like a ginger cascade.
Father in Heaven; salvation Christ made.

Twin Deer

Hidden by palmettos and leaves.
Young fawns snuggled; they did not freeze.
Filtered sunlight and summer breeze,
Warmed them beneath tall pine trees.
Freely foraging near the coast,
There were campers dreadfully close,
Heartrending sight, a glimpse at most,
Twin fawns, with the earth as their host.
Sensing grave danger in the air.
Mom nuzzled her young ones with care.
She wanted to bolt, but stayed there.
Twins fawns are so rare; humans stare.
Bravely and firmly she did stand.
She stayed there with peril at hand.
Her babies stopped there in the sand.
Mom cautiously watched for man.
Dad hid, not displaying his rack.
But mom stood alarmed; that's a fact.
One ear twitching, and one laid back.
Dreading man harbinger of love's lack.
How long would they live in this world?
Soon, that question's answer unfurled.
Enchanted by sight's precious pearl.
The camper's camcorder soon whirled.

Twisted Trunks of Trees

Oh, twisted trunks of trees
Decorated with fresh spring leaves
Adorns my window view.
I look curiously through.
A distant glimpse of traffic,
Beyond the woodland frieze
Can be seen if I look—
Through bending trees,
Daylight has peeked.
The dark of night sang.
Crickets' tunes sounded true.
Now, quietly, peacefully—
Nature sings my soul to tranquility.
And I thank God on bended knees.
Sun shines on twisted trunks of trees.
Another beautiful beginning
Finds its secret hiding place.
My heart.

Wandering Where Ospreys Fly

There's not a word that I can say
That will ease the vast pain I know.
Oh, heart and spirit live today.
My mind wants to wander and go.

I'd like to run upon the hills
Where the prickly cactus will grow.
The mountain's quiet gives its chills.
And treasures lie where ancients know.

I'd like to see the water's edge
And soar high where the Ospreys fly.
I'd hear the pirate's secret pledge.
Hidden jewels, find by and by.

What joyous sights the canyons hold.
I traverse above in the sky.
Seeing signs that show nature's gold.
Buried beneath hot sands that cry.

Come here, my friend; please ease the pain.
Wind, won't you whisper wistful words?
Sing not away this sting in vain.
Victorious wandering birds!

Weathered Faces

Time weathered faces,
Surreal beneath azure skies,
Embrace all nature.

Wildlife

Animals
Nature's fauna
Camouflaged food chain
Living, trouncing, sustaining, beautiful
Wildlife

Wind and Water

The wind sent its quiet sounds.
Whistling across sunlit terrains.
Earth recognized the tinkling tune
From past mid-summer's rain.
Then, wind and water, together
Harmonized in sweet duet.
Trickle by trickle wetness fell.
And drummed the rocks below.
Singing pleasantly through the trees.
Cascading upon wind's breeze,
Washing earth's morning glow.

Winter Traditions Cast

Feathers of ice on pine needles shine.
Sparkling glitters moments in time.
Shivers and shakes make the heart quiver.
Doves take flight from a frozen river.

Children with sleds line up on the hill.
Oh, the marvelous wintertime thrill.
Bundled up protected without chill.
Downward bound with a squeal oh, so shrill.

Distantly seen an old couple walks.
Silver hair, steamy breaths, two have talks.
Lovers embraced, smiling, happy faced.
Warmth of their hearts by hope has been graced.

Sun shining brightly glitters the snow.
Angels are made with faces aglow.
Butterfly kisses know laughs adorn.
And lifetimes of memories are born.

Alas, the dusk is taking her flight.
Icicles spruce up rooftops at night.
Footprints soon vanish into their homes.
Virgin snow falls while no one still roams.

Winter has brought a glorious sight.
Trees and snowmen all covered with white.
And so it has been for eons past.
Winter's adornment, traditions cast.

Wisteria

Life entwined as one
Unwittingly suffocates
Symbiotic death.

Woodland Fluttering

Springtime passion vine sustains; a chrysalis opens and out
emerges the **BUTTERFLY.**
Vibrant wings are held tightly together to dry before the
first thrill of **FLUTTERING!**
No longer hidden, the winged beauty stands on top of the
cocoon, displaying **COLOR**
Paralyzed while the sunlight warms and dries new wings, I
curiously walk over look **IN**
Geometric eyes that stared back at me, motionless and
probably thinking, what **THE—**On that day, I learned
that life's creatures could brighten even in the dark
WOODLAND.
And no one can see the birth of a butterfly without
realizing how wonderful life really **IS**
Caterpillars live, build a cocoon, and come forth; there
three part life is **BEAUTIFUL.**

Wrought by Plundering

Angels weep.
Nature brought to depths of hell.
Wrought by plundering.